Principles of Color Design

wucius wong Principles of Color Design

 VAN NOSTRAND REINHOLD COMPANY
New York

Printed in Hong Kong by Everbest Printing Co., Ltd.
Designed by Wucius Wong

Van Nostrand Reinhold Company Inc.
115 Fifth Avenue
New York, New York 10003

Van Nostrand Reinhold Company Limited
Molly Millars Lane
Wokingham, Berkshire RG11 2PY, England

Van Nostrand Reinhold
480 La Trobe Street
Melbourne, Victoria 3000, Australia

Macmillan of Canada
Division of Canada Publishing Corporation
164 Commander Boulevard
Agincourt, Ontario M1S 3C7, Canada

16 15 14 13 12 11 10 9 8 7 6 5 4 3 2 1

**Library of Congress Cataloging-in-Publication
Data**

Wong, Wucius.
 Principles of color design.
 Bibliography: p.
 Includes index.
 1. Color in design. I. Title.
NK1548.W66 1986 745.4 86-5598
ISBN 0-442-29284-8

CONTENTS

PREFACE

Although many books on the science of color, color systems, and color applications have been written, I have yet to find one that tackles both color and design with the aim of establishing a solid foundation for the beginner who needs to develop a personal color sense. This book was conceived to fulfill this need. It reexamines common design principles and takes a fresh look at popular color theories. Illustrations, taken from student exercises, introduce methods for systematic color thinking, which lead to ways of developing color schemes.

This text, although it is intended as an independent volume, complements my earlier book, *Principles of Two-Dimensional Design,* which is concerned exclusively with black-and-white designs. No direct reference to the other book is made here, though some common terminology exists.

Numerous illustrations and descriptions of these are presented throughout the book. Those who wish to teach themselves the color theories described herein can do so by recreating the illustrations. The illustrations will also be valuable to teachers who seek to formulate their own exercises. The concepts behind the illustrations, and the way in which the concepts are presented, are, of course, most important.

I am grateful to the students of the Swire School of Design of the Hong Kong Polytechnic, whose works illustrate most of this text. I also wish to thank Mr. Michael Farr, head of the school, for the permission to reproduce these illustrations, and Mr. Leung Kui-ting, who collaborated with me in teaching and helped me collect and photograph the illustrations. I am especially indebted to Mr. Joseph V. Canzani, president of the Columbus College of Art and Design, Columbus, Ohio, who was the first teacher to guide me into the wondrous realm of color. As always, my wife, Pansy, has assisted in the preparation of the diagrams, artwork, and manuscript to such an extent that no adequate thanks can be expressed.

PART I
DESIGN PRINCIPLES

INTRODUCTION

The design principles covered in this Part relate to discussions of color design in the later portion of the book. This is not a comprehensive examination of design, but rather a brief discussion of some common terms and basic principles governing designs with color. My purpose is to present a few essential ideas and criteria that can be effectively applied to a variety of visual situations.

Design can be seen as the visual expression of an idea. The idea is conveyed in the form of a composition. Shapes—their sizes, positions, and directions—make up the composition to which a color scheme is introduced.

In this Part, the basic elements of design—planes, lines, and points—are considered. The design area is divided into planes, and planes are subdivided into lines and then points in a series of black-and-white illustrations that introduce the ways in which students can experiment with compositions.

Formal and informal compositions are examined. Formal compositions are created with the simple mathematical concepts of translation, rotation, reflection, and dilation. Informal compositions are accomplished by considering gravity, contrast, rhythm, and center of interest. This Part ends with a close consideration of space and volume.

The illustrations were created with thin vinyl sheet material with self-adhesive backing. This material can be easily cut into rectilinear shapes and strips with a mat knife. The shapes or strips can be arranged and rearranged on a white surface before they are burnished down to form a permanent adhesion. The final effects of designs can thus be previewed, without preliminary sketches. Alternatively, black paper and rubber cement can replace the vinyl sheets, but compositions created with rubber cement are more difficult to alter.

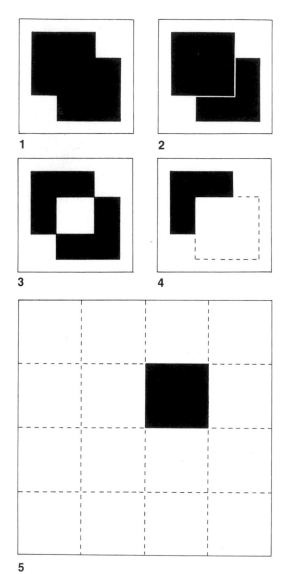

1

2

3

4

5

A design area is an uninterrupted space defined by edges. Because a square format is used here, the edges amount to four, are of equal length, and form four right angles. This uninterrupted space is then divided into sixteen equal parts (small squares). If this square is colored black, and the uninterrupted space is the white surface of paper, a black plane on white ground results (fig. 1).

The square can be moved up or down, with its edges remaining parallel to the vertical and horizontal edges of the design area. This movement produces a change in *position*. The square can also be tilted, so its edges are no longer parallel to the vertical and horizontal edges of the design area. This movement produces a change in *direction*. Changes in position and direction can be effected simultaneously.

Design decisions include the determination of positions and directions. The decision to use a square and the number of squares used may be given conditions, or may also be design decisions. When shapes overlap one another, several visual options emerge: they may be joined (fig. 2); they may be separated by a thin white line, so one shape appears to be in front of the other (fig. 3); the overlapped area becomes white (fig. 4); one shape covers a portion of another, making the overlapped part invisible—as if part of the black shape were removed (fig. 5).

Figures 6 through 9 demonstrate the use of squares as planes in design.

6

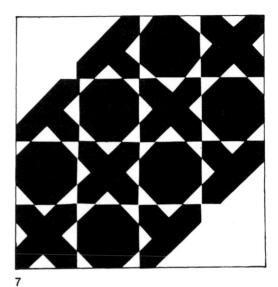

7

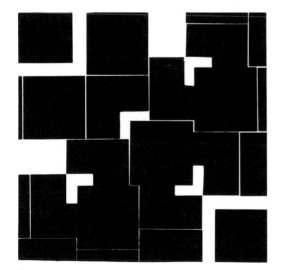

8

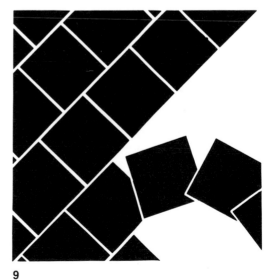

9

The square shown in figure 1 can be divided into three equal parts. Each part becomes a small elongated shape, or a *line* (fig. 10).

A line is directional; it has length but no breadth. It divides or encloses an area. It is at the edge of a shape. When breadth is present, a shape emerges. However, shapes of some length and narrow breadth are generally seen as lines, which can have:

 a. smooth or rough edges (fig. 11)

 b. squared, rounded, or pointed endings (fig. 12)

 c. a solid or textured body (fig. 13)

 d. curves or be straight in direction (fig. 14)

The shape that is defined in figure 10 and used in figures 15 through 18 is a short line with smooth edges, squared endings, a solid body, and a straight direction. Its length can be extended by joining it to, and letting it overlap, another line. The different ways of overlapping a shape, as described in figures 2 through 5, apply to lines as well.

The squared endings impose some restrictions. For instance, when two shapes are joined at the endings, they cannot form an acute angle without exposing the right-angled corners.

Figures 15 through 18 show how the line in a given shape is used in different ways. Figure 16 features some planes formed by the joining of lines.

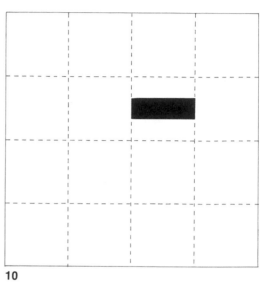

10

11

12

13

14

Lines in Design

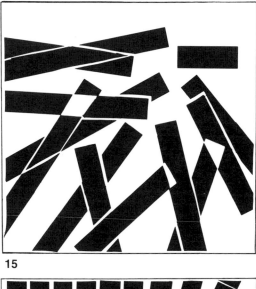

15

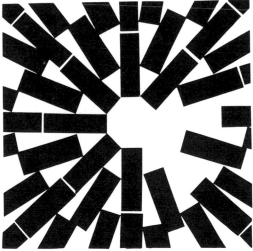

16

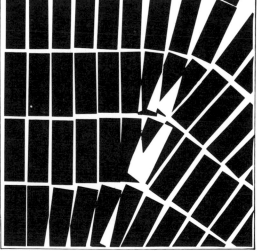

17

18

Division of the short line in figure 10 into three equal parts creates three small squares, which can be considered *points,* because they take up a relatively small portion of the design area (fig. 19).

Actually, a point denotes position alone; it should not have any length or breadth, or cover any area. This square point is a plane in miniature. Again, all the different ways that shapes can be overlapped (described in figures 2 through 5) can be applied to these points.

Most people tend to visualize points as round shapes that do not exhibit a direction when taken individually. Square points with their right-angled corners do show direction. Directions can also be established when the points are lined up or are positioned to suggest hidden lines (fig. 20).

Figures 21 through 24 are examples using numerous points as small shapes in design.

19

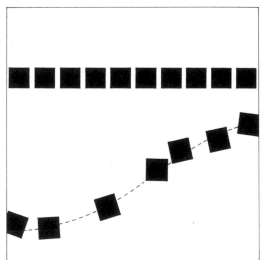

20

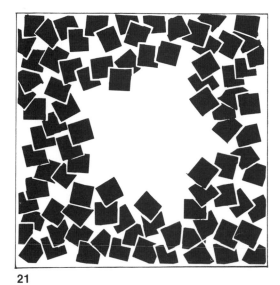

21

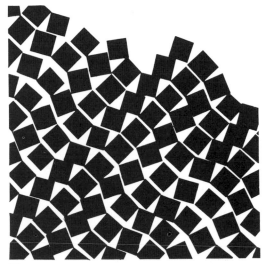

22

23

24

FORMAL COMPOSITIONS

A formal composition generally contains an underlying mathematical structure that rigidly governs the positions and the directions of elements. Rules are predetermined; nothing is left to chance. Elements are either arranged in repetition, or according to shape, size, position, direction, and/or color.

A formal composition does not always become a pattern. Overall patterns, however, are invariably based on formal compositions—the occurrence of a group of forms is predictable.

Slight deviation from the rigid rules of a formal composition results in a *semi-formal* composition, which contains anomalous elements, or loosely follows the predetermined rules.

The four ways of producing formal compositions are based on mathematical concepts of symmetry. Their combined use can lead to numerous variations. These include:

a. *translation,* or the change of position (fig. 25)

b. *rotation,* or the change of direction (fig. 26)

c. *reflection,* or creating a mirror image of the shape (fig. 27)

d. *dilation,* or the change of size (fig. 28)

25

26

27

28

Translation

The translation of a shape changes its position. The direction of the shape, however, remains unchanged. Translation is the repetition of a shape in a design. In formal compositions, translated shapes are regularly spaced. Translations can be vertical (fig. 29), horizontal (fig. 30), diagonal (fig. 31), or a combination of these (fig. 32).

The distance between shapes can be measured, once a satisfactory arrangement is obtained, by using one corner of the shape as a guide. This results in a structural grid, which serves to regulate the final design (fig. 33).

Figure 34 illustrates planes in translation.

33

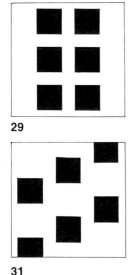

29

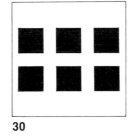

30

31

32

34

11

Rotation

The rotation of a shape results in a change in its direction. In most cases, rotation also results in a change of position, so rotated shapes are not superimposed.

Shapes radiate when they are rotated regularly about a *center of reference.* Each shape should be positioned on an imaginary axis, at equal distance from the center of reference, before rotation is effected.

Figures 35 through 38 show how four shapes are arranged in a ninety-degree rotation, resulting in formal compositions. (Broken lines represent axes, and points represent centers of reference in these diagrams.)

Figure 39 is a finished design composed of lines in rotation.

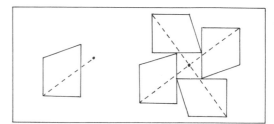

35

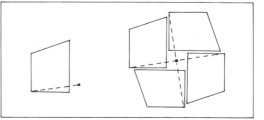

36

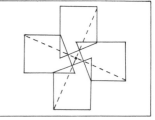

37

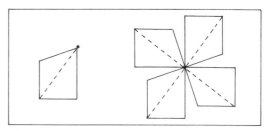

38

39

Reflection

Dilation

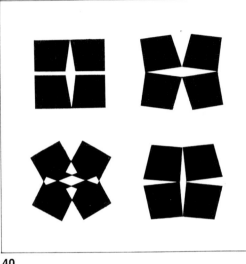

40

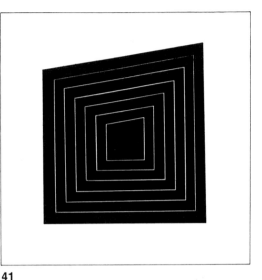

41

The reflection of a shape or a group of shapes can result in *bilateral symmetry* (a mirror image of the original shape or shapes). The original shape must be asymmetrical, because the mirror image of a symmetrical shape is no different from the original. The overall shape of a group of shapes to be reflected should be asymmetrical as well. Reflected shapes can also be translated and rotated (fig. 40).

Dilation effects changes in the *size* of shapes. The dilation of a shape that is not translated produces a regular, concentric design (fig. 41).

Dilation can be used to move shapes forward or backward in space: smaller shapes appear to be farther away; larger shapes seem closer to the viewer.

INFORMAL COMPOSITIONS

Informal compositions do not depend on mathematical calculations, but on an eye sensitive to the creation of asymmetrical balance and general unity with freely arranged elements and shapes.

No definite procedures exist, but the following may be used as criteria for evaluating informal compositions:

a. gravity—the weight and balance of shapes (fig. 42)

b. contrast—the visual (characteristics of shape and color), dimensional, or quantitative differences that distinguish one shape, part of a shape, or group of shapes from another shape, another part of the same shape, or another group of shapes (fig. 43)

c. rhythm—the suggested movement and velocity, similar to melodic developments in music (fig. 44)

d. center of interest—a focal point that either catches the viewer's eye or defines the place of convergence, divergence, or climax of rhythmic forces (fig. 45)

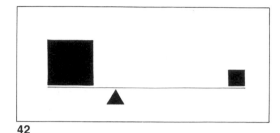

42

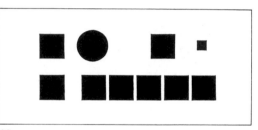

43

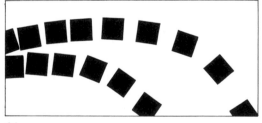

44

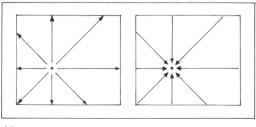

45

A designer manipulates how the weights of shapes are perceived by the viewer. Dark shapes among lighter ones on a white background, large shapes among smaller ones, tend to appear heavier. In addition, all shapes seem to be subject to a gravitational pull toward the lower edge of a design.

Gravity affects the balance of elements in a composition. Heavy shapes could be balanced with light shapes, one shape with a group of shapes. A perfectly balanced design, with each shape in its proper place, would be upset by an addition, subtraction, or the transposition of a single shape. It might also seem out of balance when viewed sideways or upside-down.

The effects of gravity can also be approximated to create stable and unstable shapes. Stable shapes have wide bases that are parallel to the bottom of the design. Unstable shapes have pointed or narrow bases. Stable shapes can be tilted to appear less stable; unstable shapes can become stable with the support of other shapes.

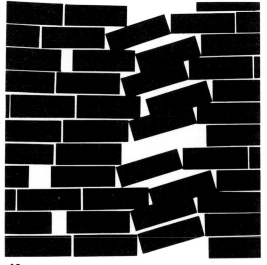

46

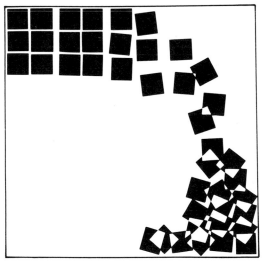

47

Contrast

Contrast is the comparison of dissimilar elements and helps to identify shapes and enhance visual variety in a composition. Aspects of contrast include not only shape, size, color, and texture, but also position, direction, and spatial effects. The quantity of shapes used and their density also affect contrast.

The antonyms heard in everyday communication can inspire the use of contrast in design: straight, crooked; square, round; protruding, intruding; sharp, blunt; regular, irregular; large, small; long, short; light, dark; brilliant, dull; rough, smooth; positive, negative; perpendicular, oblique.

In most cases, contrast is subconsciously introduced as shapes are created and arranged. Contrast is also intentionally introduced where visual emphasis is needed; insufficient contrast can result in a flat, uninteresting design. Too much contrast, on the other hand, can damage the overall unity of the design.

Contrast should generally be most apparent at the center of interest. However, it should not be introduced as an afterthought, but emerges naturally during the process of creating the design (figs. 48, 49).

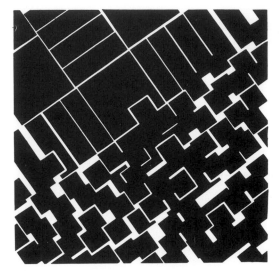

48

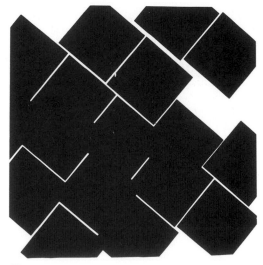

49

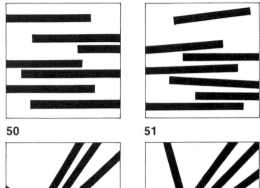

50

51

52

53

A representational design often describes a subject or theme, whereas abstract designs are frequently inspired by an idea—an event, movement, or a natural phenomenon that can be rhythmically expressed.

We are surrounded by rhythms that can be expressed as designs: ripples on a lake; birds in flight; trees spreading their branches; flowers in full bloom; clouds moving across the sky; sand scattering on a beach; a fountain spurting water; waves pounding on rocks; the bounce of a ball; an explosion of dynamite.

Abstract designs that are inspired by such ideas are not merely decorative. More important than whether or not the idea is apparent to viewers is the spirit and rhythm with which the design is infused. In addition, the idea reflects a designer's personal vision and may foster creativity.

Rhythm is generated by manipulating the directions of and spaces between elements, which may be parallel, similar, contrasting, or radiating (figs. 50–53). Wide and narrow spaces between elements suggest the velocity of movement (fig. 54).

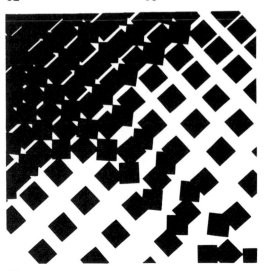

54

An informal composition must coordinate its elements around a center of interest—an area where all elements originate, cease, or interact, providing the visual drama without which the design becomes a mere conglomeration of parts (fig. 55).

A formal composition, on the other hand, does not necessarily include a center of interest, particularly if there is an overall pattern based on regular translation. A radiating design based on rotation, however, will have an obvious center of reference, and a central axis underlies designs of bilateral symmetry based on reflection. When an anomaly is introduced into a formal design, it usually becomes the center of interest of what becomes an informal composition (fig. 56).

Although a center of interest may appear in almost any part of a design, it tends to make the design static at the geometrical center; if placed at one of the four corners of a square or rectangular design, the uneven distribution of weight can upset the balance.

55

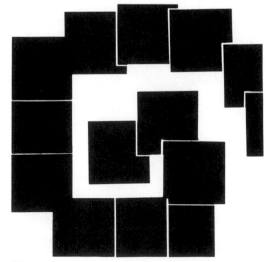

56

57

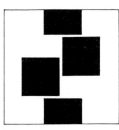

58

Designs begin as blank areas that are then activated, filled, or transformed by elements. Occupied space is usually called *positive,* unoccupied space is called *negative* space (fig. 57). The negative space between positive shapes can either be wide or narrow (fig. 58).

A negative shape can represent a solid shape that is the color of the background (fig. 59).

Space that is divided by an invisible line can result in:

a. shapes cropped by the line (fig. 60)

b. positive shapes that become negative on the other side of the line (fig. 61)

c. shapes that shift position and/or direction on the other side of the line (fig. 62)

d. the occurrence of different visual elements on the other side of the line (fig. 63)

e. positive shapes that change at the line (fig. 64)

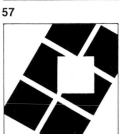

59

60

61

62

63

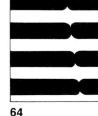

64

The Illusion of Depth in Space

A space appears to have depth when one shape overlays, but is not joined to, another. When the two shapes are the same size, the sense of depth is rather limited (fig. 65).

The illusion of greater depth can be achieved with various sizes of the same shape, as a larger shape appears to be closer to the viewer than does a smaller shape (fig. 66).

An illusion of depth can also be created by laterally turning a shape in space. A square is thus transformed into a rhombus, parallelogram, or trapezoid (fig. 67).

When lines in a sequence are bent, curved, twisted, or looped, an illusion of depth always results (figs. 68–71).

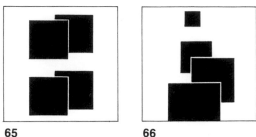

65

66

67

68

69

70

71

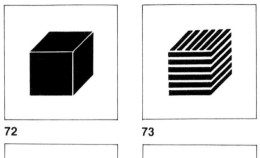

72 73

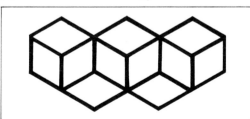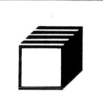

74 75

Volumes result when planes curve to form cylinders, or when planes are joined from different directions, and seem to enclose space. Planes may be solid, a sequence of lines or points, outlined, or created with a combination of these methods (figs. 72–75).

Volume construction can produce ambiguous compositions: a plane might seem to face up and down, depending on how it is viewed, and it can be part of two adjacent cubes that are seen from different angles (fig. 76).

The same cube can be arranged at different angles to form an interesting design (fig. 77).

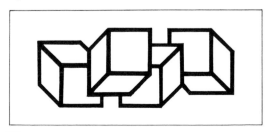

76

77

PART II
COLOR PRINCIPLES

Color perception is associated with light and the way it is reflected. Our perception of color changes when a light source is modified, or when the surface that reflects the light is stained or coated with a different pigment.

It is far easier to apply color pigments to a surface than to replace or modify a light source. Today, color pigments take many forms, come ready to use, and can be manipulated to create a variety of desirable effects.

The length of this text precludes extensive discussions of all color systems and theories. I shall therefore concentrate on color principles that are related to phenomena that can be obtained with color pigments and a stationary light source (the sun), providing consistent illumination by which all reflected colors are judged.

Theories are elaborated only as far as they are necessary for the development of a personal color sense. I do not try to advocate a single color system, although my analysis often echoes some theories of the great American colorist, Albert H. Munsell. I have based my basic color circle on Johann Wolfgang von Goethe's, an eminent German poet of the late 18th and early 19th centuries, who made important discoveries in the realm of color. I have also tried to reexamine the color circle by comparing our traditional notions of certain colors to recent scientific discoveries.

Illustrations in this Part include diagrams as well as many designs created by students, which illustrate the points raised in the text.

BLACK AND WHITE

Black, the darkest possible color, is most effectively applied to a surface, as it obliterates what originally covered it. White, the lightest possible color, is also opaque, but must be applied thickly in order to cover a surface. It is ideal, however, as a surface for receiving colors, for it can show the faintest stains and does not distort colors, though it slightly darkens them. Neither black nor white can be produced by mixing other pigments.

Black and white used together create the greatest tonal contrast with maximum legibility and economy of means. They are therefore ideal for sketching, drawing, writing, and printing. In most instances, black makes the mark, and white is the surface, accounting for the tendency to read black shapes as positive and white shapes as negative spaces.

Since we are more accustomed to black images on a white background, reversing the two colors suggests something unreal, sometimes creating a dense or heavy design (figs. 78, 79).

78

79

26

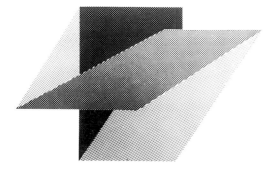

A uniform texture can be made with black on white or white on black, resulting in a flat tone that is either light or dark, depending on the proportion of black to white areas in the combination (fig. 80).

The same effect can also be achieved with fine black-and-white patterns, consisting of a regular arrangement of tiny planes, lines, or points.

In figure 81, the black-and-white elements are optically mixed and perceived as gray.

80

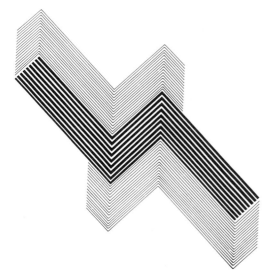

81

Tonal Transitions with Black and White

A black-and-white pattern consisting of lines or points can show a gradual change in density, subtly lightening or darkening the pattern from one part to another (fig. 82). A black-and-white texture, not necessarily as regular as a pattern, can produce a similar effect.

Although illusions of volume and depth can be achieved with black and white producing flat tones, much finer illusory effects are obtained with varying densities creating complicated areas of tonal transitions (fig. 83).

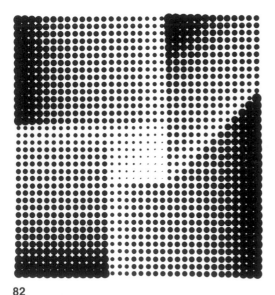

82

83

NEUTRAL COLORS

Mixing black and white pigments in varying proportions produces a range of grays. These grays together with black and white are referred to as *neutral colors*.

Although numerous steps of gray are possible, it is simpler to create only nine and arrange them into three groups.

a. The dark gray series consists of:

1—extremely dark gray (90 percent blackness);

2—very dark gray (80 percent blackness);

3—dark gray (70 percent blackness).

b. The middle gray series consists of:

4—dark middle gray (60 percent blackness);

5—middle gray (50 precent blackness);

6—light middle gray (40 percent blackness).

c. The light gray series consists of:

7—light gray (30 percent blackness);

8—very light gray (20 percent blackness);

9—extremely light gray (10 percent blackness).

These nine steps provide a basis for the accurate systematization of colors. A chart comprising the steps is called a *gray scale.* Black and white are not shown, because the scale provides light-dark comparisons to various colors, and no color is as dark as black or as light as white. Black can be given the number 0, meaning the total absence of light, and printed with 100 percent blackness, and white the number 10, meaning the maximum amount of light, and printed with 0 percent blackness.

This standard scale is a guide to visual thinking. Judging values with the naked eye can be inaccurate, since we tend to distinguish more gradations in the range of light grays than dark grays.

To obtain the grays that constitute the scale, black and white pigments can be mixed in varying proportions. The gray scale in figure 84 was produced with a mechanical device and features machine-printed halftones; black and white pigments were not physically mixed.

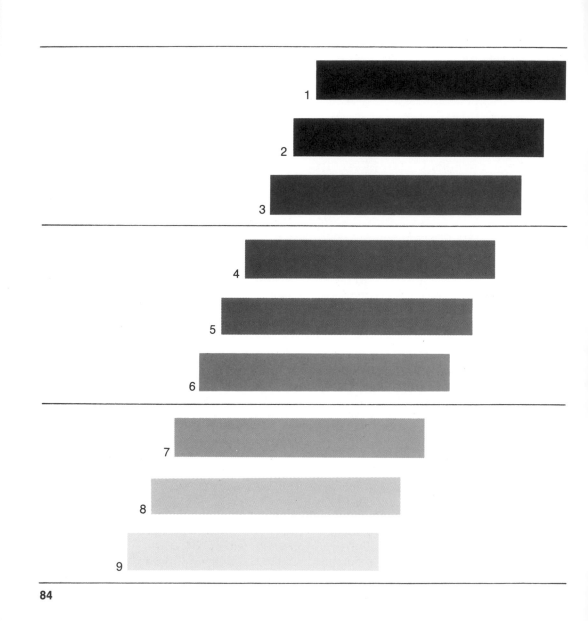

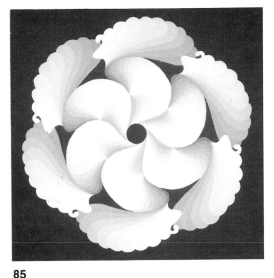

85

86

Grays are far more effective in suggesting depth and volume than black and white, which must be applied as textures and patterns to express the densities and weights of shapes and areas (fig. 85).

The terms *high key, intermediate key,* and *low key* denote particular tendencies toward specific effects. The application of neutral colors can be limited to a particular key, which emphasizes one portion instead of the entire scale.

High key describes a general lightness in the tonal expression of a design and stresses the light-gray series (see fig. 84, steps, 7, 8, 9) extending to white.

A design that exclusively features white and light grays creates a sense of mistiness and overall softness (fig. 86).

Some darker grays can be introduced for contrast, distinguishing between the expressed forms. This, however, cannot be overdone or the high-key effect will be destroyed.

Neutral colors in an intermediate key are, for the most part, in the middle-gray series (see fig. 84, steps 4, 5, 6). A design that is restricted to middle grays

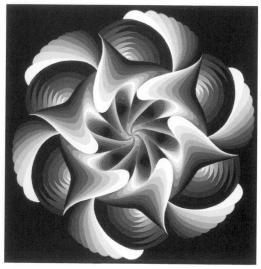

87

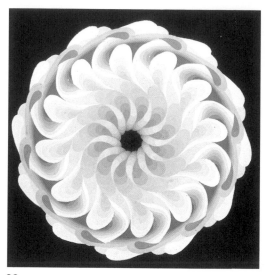

88

often lacks sparkle. A small amount of light and dark gray can add variety to the design (fig. 87).

Effective use of the intermediate key results in a well-balanced, intelligible composition.

Dark grays predominate in a low-key design, featuring the shades of gray in steps 1, 2, and 3 of the scale illustrated in figure 84. The design can also include transitions between these grays as well as black (fig. 88).

Shapes in a low-key design can be articulated and contrast introduced by adding lighter grays. This must be done subtly if the effect of a low-key design is to be maintained.

CHROMATIC COLORS

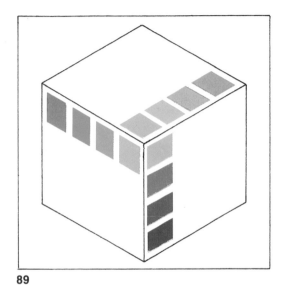

89

Our common notion of color refers to the *chromatic* colors, which relate to the spectrum as can be observed in a rainbow. Neutral colors are not part of these and can be referred to as *achromatic* colors.

Each chromatic color can be described in three ways. *Hue* is the attribute that permits colors to be classed as red, yellow, blue, and so on. The description of a hue can be more precise by identifying the color's actual inclination from one hue to the next.

For instance, a particular red may be more accurately called *orange-red.* Different color systems use different codes to describe colors made up of letters, numbers, or a combination of the two.

Value refers to the degree of lightness or darkness in any color. A color of known hue can be more accurately described by calling it either *light* or *dark.* For instance, a red is said to be light red if it is lighter than our notion of a standard red.

Chroma indicates the intensity or purity of a color. Colors with strong chroma are the most brilliant, most vivid colors that can be obtained. Colors with weak chroma are dull; they contain a large proportion of gray.

Figure 89 shows the three aspects of color—hue, value, chroma—as three dimensions of a color cube. These also resemble the letter Y in the illustration: the vertical stroke is the extension in hue; the upper-left stroke is the extension in value; and the upper-right stroke is the extension in chroma. The color swatches immediately surrounding the central Y are identical (a green hue of middle value and strong chroma). The colors move from green to yellow in the hue extension, from middle to dark in the value extension, and from brilliant to dull in the chroma extension.

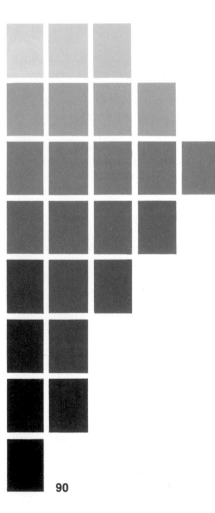

Figure 90 maps the value and chroma of a single hue. Each horizontal row represents one value level of the hue in a gradation of chroma. Each vertical row represents the hue with similar chroma in a gradation of value. Some rows are shorter, because the chroma or value in the sequence can proceed no further.

90

VALUE

The first step in the exploration of color is to use all the possible variations of a single hue. As we have seen in figure 90, by manipulating its value or chroma, a single hue can comprise a range of over twenty colors; additional transitions between colors can always be introduced. Since our vision can easily distinguish between lightness and darkness in a color, and because pigments can be more easily mixed to obtain value changes than chroma changes, we will begin by manipulating the value of a hue.

Contrasting values in a design establish distinctive shapes. Gradual value changes, however, are used to express illusions of curved planes and edges of shapes that dissolve in rippling rhythms.

Value changes can be effected by mixing the color with white and/or black pigments in varying proportions. Value can either be manipulated to maintain maximum chroma or to suppress chroma to a minimum. The two methods might also be combined for a fuller monochromatic expression.

Manipulation of Value

In order to manipulate its value and maintain maximum chroma, a hue must be of considerable brilliance. White is added to obtain steps of lighter values and black to obtain steps of darker values, but white and black are never added together. The addition of white creates clear *tints,* and black clear *shades* (no muddiness or grayness).

Using the gray scale in figure 84 as a guide, we can create nine value steps for a hue. The results resemble those forming the different steps at the right end of each horizontal row in figure 90.

The table below and left is a rough breakdown of the components of each step; W stands for white, X for black, and H for the hue.

The manipulation of value with minimum chroma makes the hue barely identifiable. To obtain the steps, white and black are mixed as different grays, and a small amount of the hue (about 10 percent) is added to each of them. The results resemble those steps forming the left vertical row in figure 90. The table below is a rough breakdown of the components of the nine steps.

9 —	W 80%	X 0%	H 20%
8 —	W 60%	X 0%	H 40%
7 —	W 40%	X 0%	H 60%
6 —	W 20%	X 0%	H 80%
5 —	W 0%	X 0%	H 100%
4 —	W 0%	X 20%	H 80%
3 —	W 0%	X 40%	H 60%
2 —	W 0%	X 60%	H 40%
1 —	W 0%	X 80%	H 20%

9 —	W 85%	X 5%	H 10%
8 —	W 75%	X 15%	H 10%
7 —	W 65%	X 25%	H 10%
6 —	W 55%	X 35%	H 10%
5 —	W 45%	X 45%	H 10%
4 —	W 35%	X 55%	H 10%
3 —	W 25%	X 65%	H 10%
2 —	W 15%	X 75%	H 10%
1 —	W 5%	X 85%	H 10%

Colors seem to dissolve when they change gradually over a surface. The strongest color can extend into steps of lighter or darker colors; light steps can follow dark steps, or dark might follow light, to introduce contrast.

Numbers corresponding to the gray scale in figure 84 can be used to plan color distributions. If gradations are arranged as 1, 2, 3, 4, and 5, the value steps proceed from dark to light. If after 8 comes a color corresponding to 2, there will be considerable value contrast. The strongest color may not always be at step 5, as a light hue would have more dark than light steps, and a dark hue more light than dark steps. Also bear in mind that the strongest color sometimes makes as great an impact as the lightest or darkest steps in a design (figs. 91, 92).

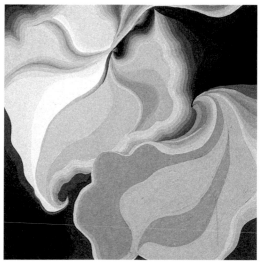

91

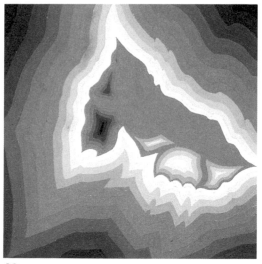

92

Value Gradations with Minimum Chroma

Value gradations with minimum chroma can be used for a subtler effect. The gradual spreading of values creates a pearllike glow, and small areas of light tend to shine amid large dark areas.

Again, the number system can be used to plan color distributions. The steps might proceed smoothly from numbers 1 through 9 without the emergence of a color with full chroma. The lightest and darkest steps tend to be most prominent, and should therefore be positioned for impact (figs. 93, 94).

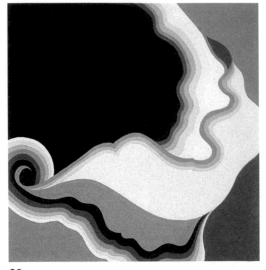

93

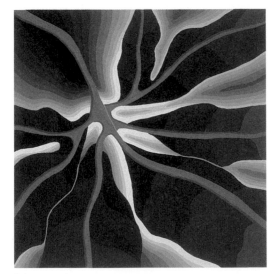

94

CHROMA

Value is key to understanding chroma, as the *value equivalent* of a hue must be determined before chroma can be effectively manipulated.

First, we should have some notion of how a specific hue with the strongest possible chroma can be compared with a particular step of gray along the gray scale. This may not be accurate, as colors of the same hue that are manufactured differently might not be equal in value. The table below, which includes names of colors commonly used, can serve as a guide. Comparing the color in question with a step of gray suggested by the table, and with slightly lighter or darker steps, can help to locate the value equivalent of the color.

Another effective way to establish the value equivalent of a color is to place a sample of that color next to each step of the gray scale. Steps that are obviously too dark or too light can be quickly eliminated. The value equivalent of the color is the step that appears no lighter or darker than the sample.

9	Extremely light gray	Lemon yellow
8	Light gray	Yellow
7	Very light gray	Orange-yellow; Golden yellow
6	Light middle gray	Orange; Yellow-green; Magenta-red
5	Middle gray	Red; Orange-red; Green; Cyan-blue
4	Dark middle gray	Green-blue; Cobalt blue; Turquoise
3	Dark gray	Purple; Ultramarine blue; Violet
2	Very dark gray	Purple-blue; Prussian blue; Indigo
1	Extremely dark gray	None

The Manipulation of Chroma

Differences in value make it difficult to detect differences in chroma. If we concentrate on the manipulation of chroma, the value of a hue must be kept relatively constant. This can be done by limiting all changes in chroma to one value step.

The establishment of a value equivalent is affected by the source of illumination. Incandescent light makes blues darker and yellows lighter. Fluorescent light has an effect on color different from that of sunlight. I prefer initially to compare a color to the steps of the gray scale in broad daylight and to check it again in a dim corner, because we are better able to discriminate between values with a low level of light.

Once the equivalent value is deter-mined, white and black pigments should be mixed to obtain the gray in that value step (pigments usually become lighter when they dry). Gray should then be mixed with the color in the appropriate proportions.

The amount of gray mixed with a color and its possible effects are described in the table below; H stands for hue, N stands for gray. The six steps shown in the table can be increased; however, the number of steps in chroma gradations are usually far fewer than those in value gradations. Once the steps exceed six, the difference between one step and the next is often too close to be recognizable. Certain hues are more suited for a wider range of chroma manipulation than others.

Strong chroma	H 100%	N 0%
Considerable chroma	H 80%	N 20%
Moderate chroma	H 60%	N 40%
Weak chroma	H 40%	N 60%
Faint chroma	H 20%	N 80%
Absence of chroma	H 0%	N 100%

Chroma Gradations with No Shift in Value

Chroma Gradations with Two Hues

95

Figure 95 shows chroma gradations of a hue with no change in its value. Ideally, all the steps should have the same level of gray in a black-and-white photograph taken of the image.

When mixing a strong color and a gray of equal value, a small amount of the gray can quickly reduce the chroma of the color. This might also lower the value, in which case a small amount of white must be added to the mixture.

It is possible to develop a design with a single hue of constant value and variations in chroma, but shapes may not emerge with sufficient clarity. In most cases, contrasting strong chroma and faint chroma, or absence of chroma, is more effective than creating fine gradations in chroma. A background of a darkened value or black is sometimes used to define shapes. If values, in addition to chroma, are varied, the result could be a full expression of the monochrome.

Until now I have discussed designs that are limited to one hue. Chroma variations or gradations are much more effective and interesting when two hues are used. The two hues do not have to be related in any particular way, but some contrast between them naturally exists. When the two colors are restricted to one value step, shapes can still be easily distinguished and an interesting color scheme results.

Two hues of the same value step are each mixed with a gray of equal value to obtain a full range of chroma gradations. If two hues have different values, these can be value adjusted by lightening the darker hue with white, or by darkening the lighter hue with black.

The hue that has not been mixed with gray has stronger chroma and will have more chroma gradations. The value-adjusted hue has weaker chroma and fewer chroma gradations.

It is also possible to adjust the value of both hues, mixing one with black and the other with white. The design that results will not feature strong chroma in any of its chroma gradations.

Figures 96 and 97 consist of two hues with the same value and gradations of chroma.

96

97

The term *hue* is often confused with *color,* but there is a distinction: variations of a single hue produce different colors. For instance, a red hue can be light red, dark red, dull or brilliant red, which are color variations within the same hue.

Nature does not provide us with the pigments to describe every hue in the spectrum; pigments that are now available are the products of human efforts throughout many centuries. We therefore have to choose pigments that closely match the standard hues.

It is common knowledge today that red, yellow, and blue can be intermixed to obtain almost any hue. Mixtures, however, weaken chroma, because of inaccurate hue expression, or the physical properties of the pigments, which come from plants, minerals, animal remains, or chemical compounds.

Regardless of these limitations, red, yellow, and blue are the three *primary hues,* and orange (a mixture of red and yellow), green (a mixture of yellow and blue), and purple (a mixture of blue and red) are the *secondary hues.* These constitute the six basic hues, which can be arranged in a circle (fig. 98).

The Six-hue Color Circle

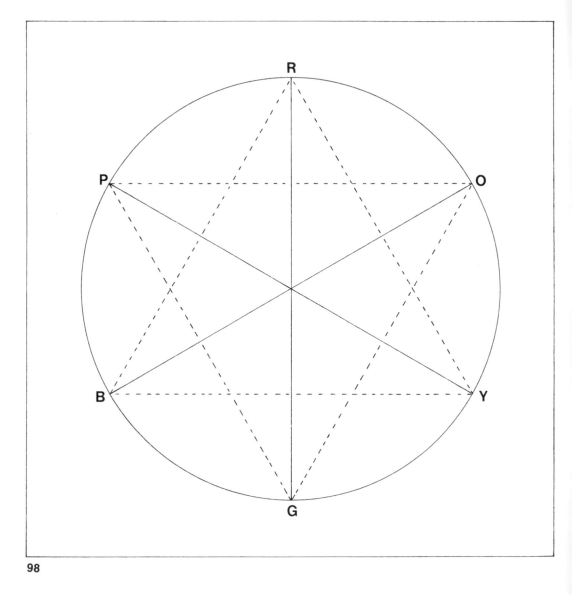

Hue Gradations with Maintenance of Chroma

To effect gradations in hue, we should choose a hue (either one of the six basic hues or their intermediates) as a starting point and another as a terminating point on the color circle. In order to maintain strong chroma throughout the transitions, the two hues are not mixed directly, but each is mixed with an adjacent hue gradually approaching the other on the color circle.

It is simplest to begin with a primary and move to another primary hue. This can be done with the two primaries alone, or with all available pigments that represent the intermediate hues. For instance, we can proceed from cadmium red to cadmium orange with cadmium yellow deep and then cadmium yellow pale. If only red and yellow pigments are used, the mixtures will weaken chroma slightly.

It is more difficult to start with a secondary hue and arrive at another secondary hue. To proceed from purple to orange via red, for instance, it is necessary to use two red pigments: a cool red, such as magenta or rose, is mixed with purple; and a warmer red, such as flame red or vermillion, is mixed with orange. Mixing the cooler with the warmer reds produces an intermediate color. Similarly, when moving from orange to green via yellow, a cool yellow, such as lemon, and a warmer yellow, such as cadmium yellow pale, may be necessary. A cool blue, such as cerulean blue, and a warmer blue, such as ultramarine blue, should be considered when moving from green to purple via blue.

Many pigments are needed to effect hue gradations and maintain chroma (see Part III for a recommended list of pigments). It is most important to acquire pigments with the strongest possible chroma, and if the pigment is a primary hue, it is necessary to determine which adjacent (secondary) hue the pigment most resembles. It is best to compare several pigments of the same hue and experiment with mixtures that produce different results.

Figures 99 and 100 show hue gradations covering one-third to one-half of the color circle. Full chroma is exhibited at every transitional step.

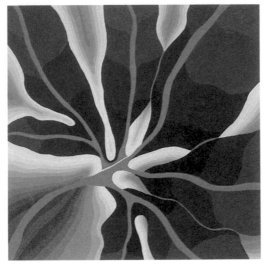

99

Knowing the positions of hues on the color circle, and mixing these appropriately with all intermediate steps, results in hue gradations with full chroma. Chroma might also be intentionally weakened (to introduce contrast of chroma) by mixing any two secondary hues, or by mixing a primary hue with the secondary hue that is opposite it on the color circle—the two hues neutralize each other and become almost gray (fig. 101).

Another way to weaken chroma is to mix a primary hue with one adjacent (secondary) hue. For instance, a purple-biased blue mixed with green produces a much duller blue-green than would result from mixing a green-biased blue with green.

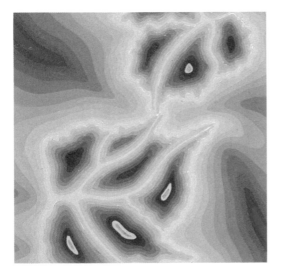

100

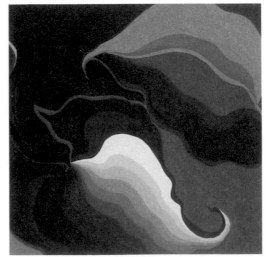

101

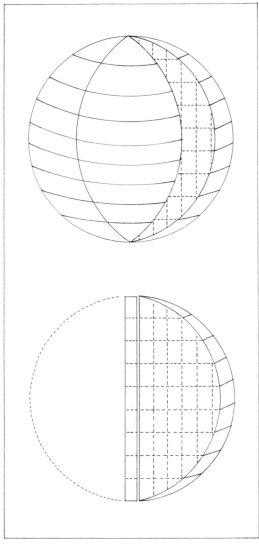

The three aspects of color—value, chroma, and hue—might be described as the dimensions of color and represented by a color solid. Different color systems use different solids to describe the relationships between colors; the color circle, used here, is most easily transformed into a sphere.

The sphere is composed of segments that represent specific hues in the spectrum. Six segments represent the six basic hues—red, orange, yellow, green, blue, and purple. If the sphere is horizontally divided, a color circle is revealed. The hue contained in each segment is represented in a variety of values (see fig. 89). The upper part of the sphere is of higher value, approaching white at the top, and the lower part grows darker, becoming almost black at the bottom.

The inward-facing straight edge of the segment shows the hue in value gradations of minimum chroma. The outward-facing, curved side of the segment shows the hue in value gradations of maximum chroma. The strongest chroma occurs where bulging is most prominent. Amid the segments is a columnar section that represents the gray scale, with white gradually descending to black (fig. 102).

102

The sphere can be thought of as a globe. At the north pole is white and at the south pole black. Between the two poles, eight parallel latitude lines can be drawn, creating nine value zones, with the middle value zone covering the equator. Longitudinal lines divide the globe into six hue zones. Not all the hues in full chroma appear along the equator—the intrinsic value of a hue determines whether it appears in full chroma at the upper or lower portion of its zone. For instance, the strongest chroma of yellow, because it is of light value, occupies a position in the upper portion of the yellow zone. The strongest chroma of blue, because it is of relatively dark value, occupies a position in the so-called southern hemisphere. Figure 103 shows the two sides of this color globe; the location of the strongest chroma of each hue is indicated with black dots.

The sphere bulges wherever the strongest chroma occurs in each hue zone. The globe is therefore distorted in the appropriate places.

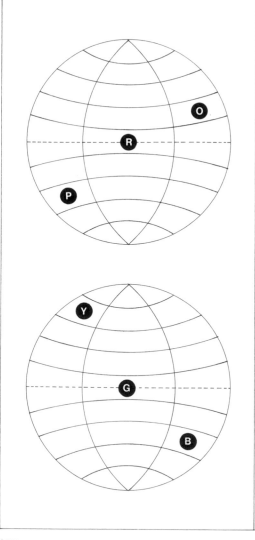

103

If the value zones in the globe (see fig. 103) are numbered, just as the steps of the gray scale were numbered in figure 84, we can compare different hues of the same value.

Figures 104–8 show how the six basic hues appear at the more common value zones and illustrate the way different hues can be value adjusted. In value zone 8, yellow is of strong chroma, but blue and purple are of faint chroma (fig. 104). At zone 7, orange-yellow is strong (fig. 105). At zone 6, orange and yellow-green are beginning to appear strong (fig. 106). At zone 5, red and green are at full chroma strength (fig. 107). At zone 4, blue-green, blue, and purple display considerable brilliance (fig. 108).

104

105

106

107

108

COMPLEMENTARY HUES

Hues directly opposite each other on the color circle are called *complementary* hues. The six-hue color circle in figure 98 contains three pairs of complementary hues:

Red (R) and Green (G)
Yellow (Y) and Purple (P)
Blue (B) and Orange (O)

When a hue and its complement are mixed, they neutralize each other, resulting in a muddy gray or brownish color. Mixing the three primary hues also produces a neutral color. These phenomena are described in the simple formulas below, where N stands for the neutral color:

$O = R + Y$
$G = Y + B$
$P = B + R$
$N = R + Y + B$
$R + G = R + Y + B = N$
$Y + P = Y + B + R = N$
$B + O = B + R + Y = N$

The six-hue color circle can be expanded to form a twelve-hue color circle (fig. 109); three pairs of complementary colors have thus been added:

Red-orange and Green-blue
Orange-yellow and Blue-purple
Yellow-green and Purple-red

There is some contrast between any two hues, but complementary hues exhibit the strongest hue contrast,

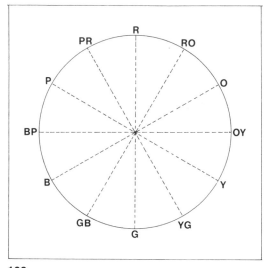

109

which can be even further enhanced if they are of the same value (figs. 104–8).

Near-complementary hues—two hues that are not directly opposite each other on the color circle, such as red and blue-green, red-orange and green—can be used in place of strict complementary hues to obtain similar effects. In any pair of complementary hues, each hue can split into two or more hues (R can become purple-red and red-orange) or develop separate ranges of value and chroma variations.

Because tastes change from generation to generation and according to an individual's age, sex, race, education, cultural background, and so on, it is difficult to establish specific rules for creating effective color combinations.

For our purposes, color harmony is best defined as successful color combinations, whether these please the eye by using analogous colors, or excite the eye with contrasts. *Analogy* and *contrast* are thus the two approaches to achieving color harmony. To evaluate these in a design, we must individually consider the value, chroma, and hue of colors.

The color circle in figure 92 can be used as the basis for creating hue harmony. The simplest color scheme that can be created using analogous hues is monochromatic, restricted to one hue. Alternatively, analogous hues can be taken from a portion of the color circle, say, the colors contained within 60 to 90 degrees, and can be randomly juxtaposed or used in gradation within a design.

Analogous hues also result from a common hue bias—a tiny quantity of a particular hue is mixed into each color, sometimes changing its hue, value, and/or chroma in the process. For instance, orange-yellow can be mixed with all colors, creating an overall orange-yellow cast—a tropical color scheme.

Hues contrast significantly when they are separated by 90 degrees or more on the color circle. The wider the distance between the hues on the circle, the greater the hue contrast.

Both analogy and contrast are present in a color scheme if hue gradations cover a large portion of the color circle.

Value Harmony

Chroma Harmony

The gray scale in figure 84 can be used as the basis for creating value harmony. A design with analogous values restricts hue and chroma gradations to adjacent, or just one, value steps (see figs. 104–8).

Designs with value gradations can have colors juxtaposed from value steps 2, 4, 6, and 8, or steps 2, 5, and 8 for some value contrast. A design that emphasizes value contrast might have very dark accents in a high-key design, or very light accents in a low-key design.

The concepts of analogy and contrast also apply to chroma harmony. Colors that have the same degree of chroma strength have analogous chroma. Hue gradations with maintenance of chroma therefore result in analogous chroma. Colors in full chroma throughout a design emphasize hue contrast, and weak chroma throughout neutralizes hues and diminishes hue contrast.

Chroma contrast is best effected by restricting colors to one value step, allowing each color to diplay either strong or weak chroma. Hue gradations with chroma changes result in chroma contrast, as some colors have weakened chroma after they are mixed.

Value, chroma, and hue must all be considered, even when only one of these is manipulated to establish color harmony.

SIMULTANEOUS CONTRAST

The Change of Hue in Simultaneous Contrast

When combining colors, we must pay attention to the effects of simultaneous contrast, which can alter the way colors are perceived. Simultaneous contrast refers to the apparent changes in hue, value, and/or chroma that are created by adjacent colors. Visual stimulation causes the eye to generate an after-image that is in the hue complementary to the original image. This most often occurs when one color surrounds another (the surrounded color is altered by the surrounding color).

Earlier, when complementary hues were first discussed, I introduced a total of six complementary pairs: red and green; yellow and purple; blue and orange; red-orange and green-blue; yellow-green and purple-red; blue-purple and orange-yellow. For the purpose of understanding simultaneous contrast, white and black may also be considered complementary.

We can experiment with simultaneous contrast by gathering a wide range of color specimens—colored paper or painted chips—that show a variety of hues with variations in value and chroma. If we punch a hole in each colored chip and look through these at the same color, we can see how the value, chroma, or hue of the color changes as a result of simultaneous contrast. It is possible to make two dissimilar colors look nearly the same by viewing them through particular colored chips.

110　　　　　**111**

A surrounded color exhibits a change in hue, because it is optically blended with the afterimage of the surrounding color, which is of a different hue. For instance, when orange is surrounded by green, the afterimage of green (that is, its complement, red) tints the orange and makes it appear much redder. If the same orange is surrounded by purple, the afterimage of purple (that is, its complement, yellow) tints the orange and makes it appear much more yellow. It is important to understand the principles that govern simultaneous contrast, so its effects can be predicted (figs. 110, 111).

We can see the afterimage of a color by staring at a small color sample laid on white paper. If, after thirty seconds or more, our eyes shift from the color sample to the white background, we see an illusion of the shape of the color sample in its complementary hue.

The Change of Value in Simultaneous Contrast

The Change of Chroma in Simultaneous Contrast

A change of value occurs when a surrounded color is much lighter or darker than the surrounding color. If the surrounding color is light, the surrounded color appears darker; if the surrounding color is dark, the surrounded color appears lighter (figs. 112, 113).

In simultaneous contrast, a change of chroma can be detected if the brilliance of the color seems enhanced, or if the color seems dulled. We can again use the color circle in figure 92 to predict the results.

When a color is surrounded by another that is in its complementary hue, this color is strengthened in chroma, because the afterimage of the surrounding color is of the same hue as the surrounded color. The surrounded color thus becomes more radiant, taking on an almost fluorescent glow. For maximum effect there should be little value contrast; in other words, one color should be value adjusted to the other (fig. 114).

When two colors being related are within 90 degrees of each other on the color circle, simultaneous contrast will weaken the chroma. For example, red surrounded by orange will be affected by the complementary hue of orange—green. The red would gray slightly, as the green cast has a neutralizing effect (fig. 115).

112

113

114

115

REEXAMINING THE COLOR CIRCLE

Names and terms relating to colors are part of our cultural tradition. Conditioned by the culture in which we are raised, we form fixed notions of how red, orange, yellow, green, blue, and purple should appear. Most people, for instance, still consider an orange-biased red to be the standard hue of red.

Most color systems developed in the early part of this century are based on a set of primary hues that are different from the primary hues science has brought to light. These primary hues—magenta-red, yellow, and cyan-blue (with black to reinforce value contrast)—are used today for printing. Practically any color can be obtained with these four basic pigments. Whereas black is considered opaque, the other three are generally transparent; they are printed on white surfaces as solid planes, or in tints of specific percentages that overlap.

Magenta-red is perceived as a purple-biased red, with a lighter value than our usual notion of red; the yellow used in printing is a bit cooler and lighter than what most consider a typical yellow. The secondary colors obtained from these primaries are an orange-red (which is far more red than orange), a blue-biased purple, and a green that is similar to our notion of green.

It is interesting to compare these new sets of primaries and secondaries with those that older color systems were based on. The cover of this book shows the two color circles superimposed, with the scientific color circle on the outer and the traditional color circle on the inner ring. The colors are not in full alignment. The primary colors in the scientific color circle have distinct advantages (magenta-red can mix with yellow to form orange, with cyan-blue to form purple, and cyan-blue can mix with yellow to form green—all without weakening chroma).

However, since most of us still think of colors as they appear on the traditional, rather than the scientific, color circle, and since colors represented on the scientific color circle are fugitive dyes, unsuitable for artists whose colors must have a considerable degree of permanency, the traditional color circle is a more useful tool for our purposes. The scientific color circle should be considered only in special situations.

PART III
COLOR DESIGN

The information gathered in this Part has been taken from different periods of my teaching career. This is reflected in the illustrations, which were created by students in my color design course. These illustrations include abstract designs with points, lines, and planes; geometrical designs with rigid structures; and organic designs based on natural forms. This variety, I believe, offers the reader an opportunity to consider the alternatives and to compare different approaches.

By presenting formal and informal compositions and exploring analogy and contrast in hue, value, and chroma, design and color concepts are thus brought together in a variety of ways. Each illustration represents an attempt to create an effective color scheme, which is the principal aim of this text.

Few tools are required to create color designs. In addition to the basics like pencils, erasers, rulers, and set squares, there are brushes, ruling pens, and bow compasses.

Red sable watercolor brushes with round points are recommended for applying paint to small areas. Wash brushes with flat points (made of soft animal hair) are good for applying paint to large areas. For rectilinear shapes, a ruling pen could be used with more liquefied colors to establish edges before brushes are used to fill in the color. A bow compass can similarly be used for the edges of circular shapes.

White bond paper is generally adequate for sketching, or for initial color visualizations with felt-tip markers. An illustration board of medium grain with a white surface is ideal at later stages of the design process.

The pigments to be used are poster colors that typically come in glass or plastic jars. Designers' colors or gouache colors, which come in tubes, can also be used. The colors must be of a good grade, brilliant enough to express hues of strong chroma, and able to be smoothly applied.

The following is a recommended list of brand name poster colors (the same color produced by two manufacturers might bear different names):

R	Rose Transparent, Vermillion, or Flame Red
O	Cadmium Orange
Y	Cadmium Lemon, Cadmium Yellow Pale
G	Cyprus Green
B	Cerulean Blue, Ultramarine Pale
P	Purple
W	White
X	Lamp Black, or Ivory Black

The list is rather long, but certain colors should be priorities. We should begin with white, black, and the three scientific primaries (magenta-red, yellow, and cyan-blue). Rose Transparent is probably the closest poster color to magenta-red; Cerulean Blue might replace cyan-blue; Cadmium Lemon matches the primary yellow; Cadmium Yellow Pale is not far off. These colors can be mixed to obtain secondary hues.

The next color to acquire is a traditional orange-biased red, such as Vermillion or Flame Red. You should then get a purple-biased blue—Ultramarine Pale.

For hue gradations that maintain strong chroma, secondaries can be useful—Cadmium Orange and Cyprus Green. Purple can be added last, or not at all, as a mixture of Rose Transparent and Ultramarine Pale produces an adequate substitute.

Many people like to include such colors as brown and yellow ochre. Brown is a combination of orange and black; introducing a bit of purple to yellow produces yellow ochre. These are therefore not essential.

DESIGNS WITH VALUE GRADATIONS

The neutral colors are not necessary for color design exercises, as the manipulation of values with minimum chroma in a design create the same effects as designing with neutral colors.

The faint tint of color in designs with minimum chroma can lend a sense of warmth or coolness to a composition. The presence of such a tint of a hue is more noticeable when there are other hues with which to compare it. For instance, figure 116 has a yellowish cast, whereas figure 121 appears brownish, because an orange hue is present. Both designs show value gradations with minimum chroma.

Value gradations maintaining maximum chroma emphasize the hue. When value steps in a design cover a wide range, the value step with the hue at its strongest chroma is most prominent (figs. 122, 123). This is less apparent in figure 120, because the light background tends to darken the hue as a result of simultaneous contrast. Figure 118 features the hue purple-red (which is already a middle value) as the lightest value step. This shortens the value range, reduces value contrast, and enhances chroma contrast, establishing a low-key effect with hue shining in the dark.

Value gradations are effective for creating spatial illusions. Low values against a very dark background fade into the distance, but high values seem to move forward (figs. 116–19, 121, 122). Against a very light background, dark values seem to move forward, and light values fade into the background (fig. 120).

Figure 123 shows a background of middle value, making both light and dark values stand out. The spatial effects are ambiguous, which is the aim in this design.

Points as Lines in Value Gradations

Points as Planes in Value Gradations

Value gradations can be effected with a sequence of points arranged in lines. The size of points, either round or oval, has to be uniform within one design.

A single round point has no direction, but in a sequence, points become lines that must have an inclination. Overlapping points enhance a sense of depth, particularly in figure 121, where the rows of points seem to laterally penetrate the space behind.

When points are arranged in adjacent lines, they form planes. Points are the textural components of planes (see figs. 122, 123).

Figure 122 features a ribbonlike plane that curves in space; its light values create a metallic glow.

The value gradations of the oval points arranged as square planes in figure 123 suggest diagonals, which do not actually exist in the design.

Designs with Value Gradations

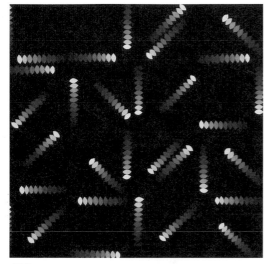

116

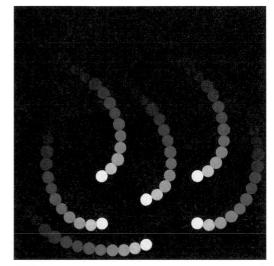

117

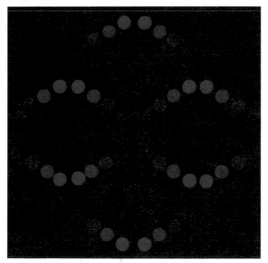

118

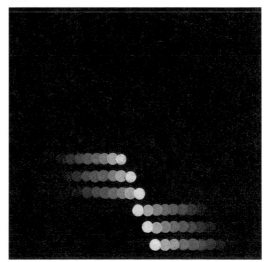

119

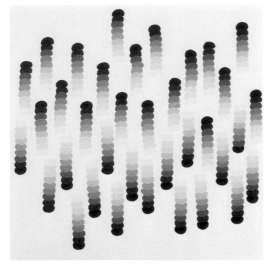

120

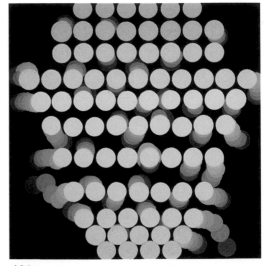

121

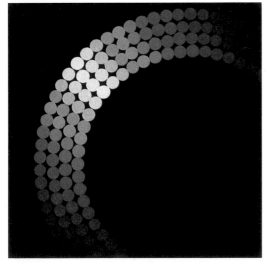

122

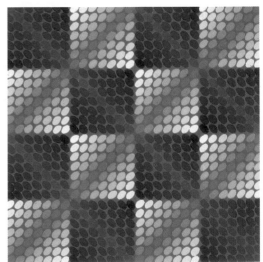

123

DESIGNS WITH CHROMA GRADATIONS

Differences in chroma among colors of the same hue are best expressed with minimum variations in value. There are fewer gradations of chroma than of value in color, and the clarity of shapes should be maintained when manipulating chroma. Therefore designs that stress the effects of chroma should not be overly complicated, and chroma gradations should have apparent steps and simple rhythms. A dark background is effective, because the colors are heightened by contrast, appearing more luminous.

The illustration included herein may not show all colors with uniform values, because colors are slightly distorted when reproduced. Figures 127 and 130, however, maintain values that are closely related more successfully than the others.

Figures 126 and 129 use a lighter value for the chroma gradations. The strongest chroma step is therefore weaker than that of the other examples, producing a soft image.

Figure 128 contains a dark background as well as several dark planes of slightly lighter value than the background. Values vary here more than in the other designs.

Two hues instead of one were used to create the design in figure 131. Because one hue is darker than the other, the design shows considerable value as well as hue contrast in addition to gradations of chroma.

Lines as Bands in Chroma Gradations

Shapes as Patterns in Chroma Gradations

Sequential lines can form ribbonlike bands that bend, fold, twist, or knot (see figs. 124, 126, 127, and 129). Figure 125 shows only straight bands. Fig. 128 shows a band in disarray at one end and intercepted with solid planes.

Chroma gradations cannot be easily manipulated to create illusions of depth as can value gradations. We might expect the strongest chroma to advance and the weakest chroma to recede in space, but if the chroma gradations vary slightly in value, the darker values recede and the lighter values advance on a dark background regardless of the chroma strength. Bands of color, however, can suggest a tubular shape, especially in figure 127, where the strongest chroma is at the center of the band (see also figs. 125, 129).

Figures 130 and 131 demonstrate how shapes can be used to create patterns in chroma gradations. The shapes are actually birds that appear as planes in figure 130 and as line and plane combinations in figure 131.

The shapes in figure 130 are first rotated and then translated. The rotation consists of six birds, which together become a super-unit form that is then translated in a staggered grid. There is little depth illusion except that the strong orange advances slightly.

Figure 131 also features a super-unit form in translation—four birds arranged in two groups. Each group has two overlapping birds and is rotated 180 degrees from the other group within the super-unit form. The pattern emphasizes a diagonal arrangement.

Designs with Chroma Gradations

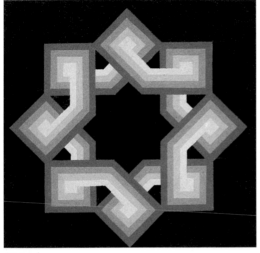

124

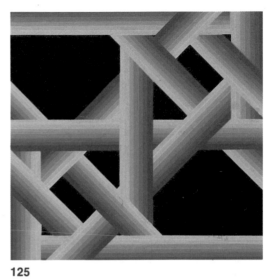

125

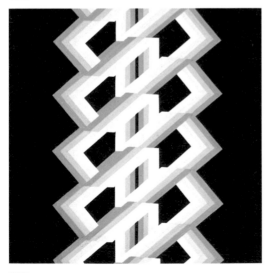

126

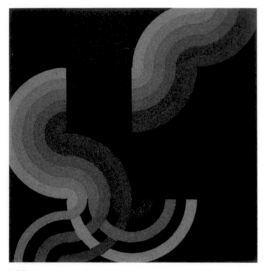

128

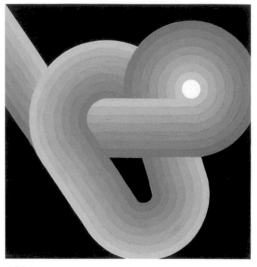

129

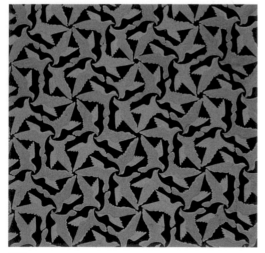

130

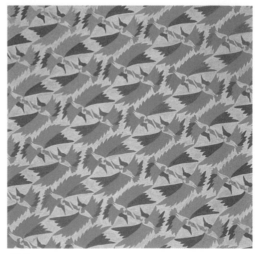

131

DESIGNS WITH HUE GRADATIONS

In value gradations, only one hue is introduced with chroma either in maximum or minimum expression. In chroma gradations, one or two hues can be used with slight changes in value. In hue gradations, a wide range of hues allows for a fuller expression of color. When effecting hue gradations, we can either maintain consistent value or chroma, but not both. Hues at full chroma strength differ considerably in value (see discussion of the color solid in Part II). When all the hues are confined to one value step, value-adjusted hues normally show a weakening of chroma.

To establish a range of hue gradations, it is necessary to determine the following:

 a. the first hue in the range

 b. the last hue in the range

 c. the number of steps in the gradation

 d. how hue transition is effected

Fixing the first and last hues in the range determines whether the range will be narrow or wide. A narrow range comprises analogous hues, as in figure 133, which contains hues that are within 60 degrees of each other on the color circle. When a design contains a wide range of hues, these can encompass half of the color circle (fig. 135), or even the whole color circle in exceptional cases.

The number of steps in the gradation depends on the design. More steps of gradation effect slow changes in hue and produce a smooth design (fig. 136). Fewer steps of gradation effect rapid changes, which quicken the rhythm and increase the contrast in the final image (figs. 137, 138).

The way chroma strength is maintained or changed affects the transition between hues. Figures 132, 133, 135, and 136 are examples of hue gradations in full chroma throughout the transitions; figs. 134, 137, 138, and 139 show some weakening of chroma among the greens, due to mixtures of yellow and purple-biased blue hues. Hues that are a great distance from each other on the color circle can be mixed directly to produce a range of hue gradations with a marked reduction of chroma strength.

Figures 132 through 134 are composed of sequences of lines that form bands. Refer to figures 125 through 129 to see how hue gradations are different in effect from chroma gradations. In hue gradations, yellow, the hue with the lightest value, is the most visible, particularly on dark backgrounds. Value still plays an important role in the creation of spatial illusions.

Figures 135 through 137 feature lines floating in space. In figure 135, two sets of parallel lines are at right angles to each other, with one vertical line bisecting the angle. Analogous colors appear on the left side of the design, but proceed toward complementary contrast, clearly represented by the green vertical line on the red background.

The lines in figure 136 gradually change direction, creating a loop in space. The lines in figure 137 change direction as if being pulled by gravity.

The design area was divided into flat planes before the lines were positioned in figures 138 and 139. The planes tend to impose a pattern, confining the movements of the lines and restricting the play of illusory space by limiting depth. Both figures also show changes in chroma strength in the hue gradations, particularly noticeable in the weaker chroma of the green hues.

Figure 138 features parallel lines in two directions; the yellow lines stand out more than others. Hue gradations are not orderly arranged.

The lines in figure 139 go in all directions. The progress of hue gradations in the planes is the reverse of that in the lines, and hue contrast is the least prominent among the central planes.

Designs with Hue Gradations

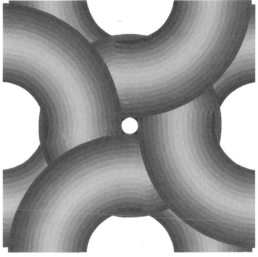

132

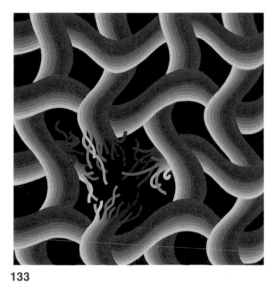

133

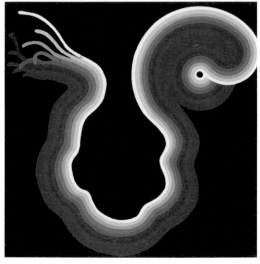

134

135

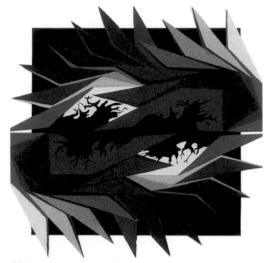

136

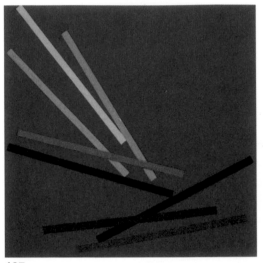

137

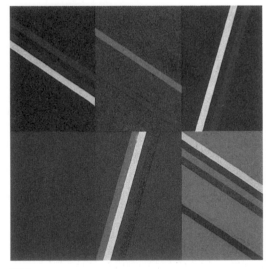

138

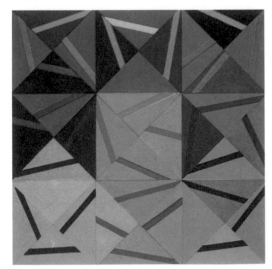

139

DESIGNS WITH HUE MIXTURES

Warm/Cool Sensations Generated by Hues

Any two hues can be mixed to form a range of hue gradations. If they are analogous and are correctly biased, the hue gradations that result maintain considerable chroma strength (fig. 140). If they are not analogous and/or not correctly biased, the result will show weaker chroma in the mixtures (figs. 141, 145, 146). When complementary hues are mixed, chroma weakens to a significant degree (figs. 142, 143, 147).

The presence of weakened chroma in the range of hue gradations enhances chroma contrast, because the two original hues stand out distinctly from their mixtures.

Our knowledge of hue is incomplete without an understanding of warm/cool sensations generated by hues. A *warm* sensation is created with the presence of the hue associated with fire—orange (a mixture of red and yellow). Any hue containing red, yellow, or both expresses warmth. A *cool* sensation is generated by the presence of the hue associated with water or sky—blue. A hue containing blue expresses coolness.

The warmth or coolness of a hue, however, is relative; a hue may seem warm when compared with a cooler hue and cool when compared with a warmer hue. The greater the amount of red or yellow in a hue, the warmer it appears. Likewise, the more blue present in a hue, the cooler it seems. Green, for instance, has an equal amount of yellow and blue. It seems warm when compared with blue-green, which contains more blue, but appears cool when compared with yellow-green, which contains more yellow. The hues between red and yellow are all warm; it is difficult to compare warm and cool effects among these, though hues closer to the standard orange are generally considered warmer.

Warm/cool sensations also affect spatial illusion in a design. Because warm hues seem to advance whereas cool hues seem to recede, the warmth or coolness of elements in a design can effectively express space. The way a

hue relates to its background is also important. It tends to stand out if contrast with the background is great, and to fade when it blends into the background.

Hues can be mixed to establish a smooth transition between warm and cool sensations. At a certain stage in the mixture, the color may exhibit no inclination toward warmth or coolness.

Simultaneous contrast resulting in a change of chroma significantly affects the warm/cool sensations. A strong warm color can make a weaker color of the same hue look cool, and conversely, a strong cool color can make a weaker color of the same hue look warm.

A sequence of overlapping planes expresses an illusion of depth that is further enhanced with hue gradations. This illusion works especially well if the colors at one end of the range blend into the background (fig. 140).

Most of the examples here display ambiguous spatial effects, particularly figures 143 and 146. Figures 140 and 141 feature flat curvilinear planes; others are rectilinear shapes that are rotated and/or translated into stacked, bent, folded, or torn configurations.

In figures 146 and 147, the hues that are mixed are also given value variations or gradations.

Designs with Hue Mixtures

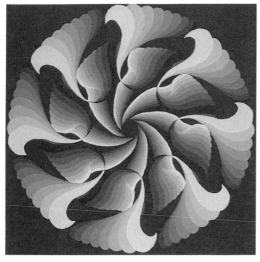

140

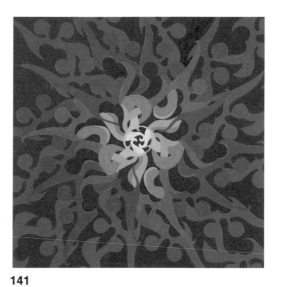

141

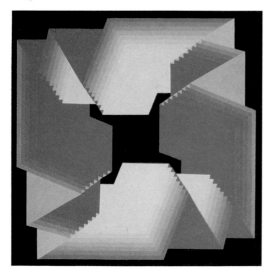

142

143

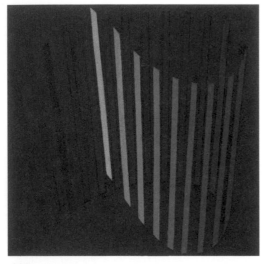

144

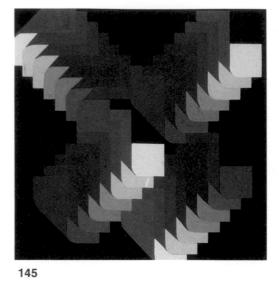

145

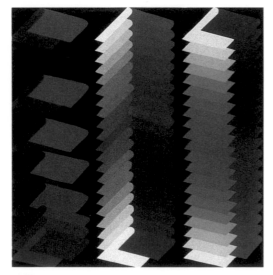

146

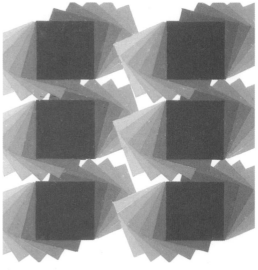

147

DESIGNS WITH COMPLEMENTARY HUES

Split-complementary Hues

Complementary hues lie on opposite sides of the color circle. They produce the greatest hue contrast, especially when value differences are minimal. Eye-catching designs are therefore generally created using complemetary hues.

Hues that are not exactly 180 degrees apart on the color circle are considered near-complementary hues and have effects similar to complementary hues.

Split-complementary hues establish a multicolored scheme with analogous and contrasting color relationships. Split-complementary hues are obtained by replacing one of the complementary hues with the hues adjacent to it on the color circle. Red and green thus become red and yellow-green, green-blue; or, purple-red, red-orange, and green.

It is also possible to split hues without replacing any of the complements. For instance, the complements of red and green can become split complements by including yellow-green and blue-green, or purple-red and red-orange.

Splitting one of the complementary hues in a pair produces three or four hues, and splitting both produces even more. A multicolored scheme with analogous and contrasting hues is thus created.

Near-complementary hues are split in a similar way.

Illusory Volumes Created with Complementary Hues

Creating Patterns with Complementary Hues

Figures 148 through 153 all feature illusions of volume using complementary hues. Blue, red-orange, and orange-yellow form a split-complementary color scheme in figures 152 and 153. With the blue hue slightly heightened in value, the three hues are seen roughly in the value steps of 4, 6, and 8, adding visual clarification to the three-dimensional illusions.

Figures 148 through 151 explore ambiguous representations of volume and space with the direct mixing of complementary hues. Figure 148 also incorporates value variations in the process of hue intermixing.

The compositions in figures 148, 149, 150, and 152 display a wide expanse of background, which tends to emphasize depth.

Figures 154 and 155 have overall patterns created with invisible lines that form a grid made up of numerous spatial cells (subdivisions of space). Shapes are generally confined to the spatial cells, but sometimes introduce variations and accentuations that keep the designs from becoming monotonous patterns.

Split-complementary hues are used in both illustrations. A scintillating effect results from hues of closely related value, which is particularly obvious in the reds and greens of figure 155.

Designs with Complementary Hues

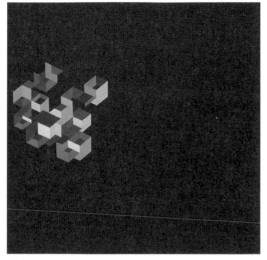

148

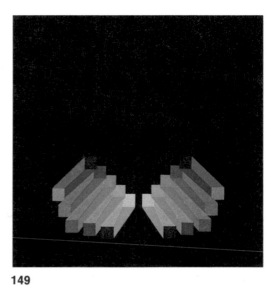

149

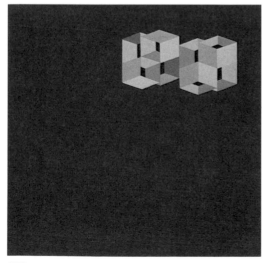

150

151

152

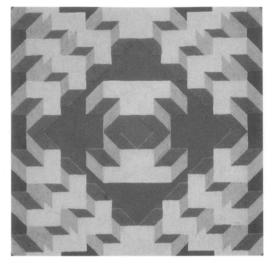

153

154

155

Complementary Hues with Hue Gradations

Complementary Hues with Value Gradations

Either or both of the complementary hues in a color scheme can, instead of splitting into its adjacent hues, mix with these to produce a range of color gradations. Dissolving effects are achieved if the gradations are smooth (figs. 156, 157).

Figure 158 demonstrates the same effect, although the hue gradations actually extend to cover half the colors in the color circle. The large planes, however, are of complementary hues and therefore dominate the color scheme. The edges of the planes are softened with sequential lines forming hue gradations.

Figures 159 through 161 explore complementary hues with value gradations. Figure 161 also shows a bit of hue intermixing. The value effects in these illustrations are more apparent than the contrast between the complementary hues, which rarely exhibit strong chroma when they are adjacent.

The informal composition in figure 160 is divided into three parts by invisible lines, which interrupt only slightly the continuity of shapes.

Figure 161 is a formal composition with bilateral symmetry; dissecting invisible straight lines form four rectangular panels in the lower-middle portion of the design. The image is reflected along a central axis, but one hue sometimes changes to the other on the opposite side of the axis.

The design area in figure 159 is formally divided into regular spatial cells, and there are concentric dilations. The image is based on a kind of flower, which is not presented as a regular shape with repetitive, symmetrical elements. The regular and irregular aspects, however, make the design interesting. The complementary hues in their full chroma are more closely related here than they are in figures 160 and 161. Because red and green are at the same value step, there is strong contrast between hues and the design scintillates.

When the design area is divided, it becomes spatially transformed; it

seems as if something transparent, or with refracting or reflecting properties, were superimposed on the design. Each part of the design might be spatially autonomous, with shapes and background only indirectly related to adjacent parts.

Complementary hues with chroma gradations are illustrated in figures 162 and 163. Both are pattern designs featuring pairs of birds formed by 180-degree rotations, and then regularly translated. A black background clarifies the shapes.

Although the design concept in these illustrations is similar to that of figures 130 and 131, complementary hues provide strong accentuation when colors have full chroma.

More Designs with Complementary Hues

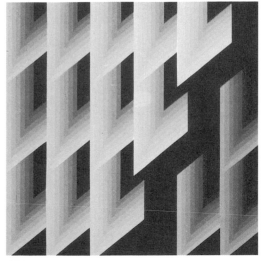

156

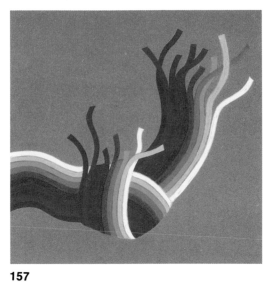

157

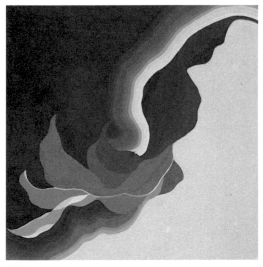

158

159

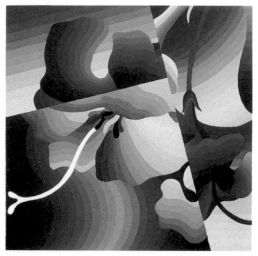

160

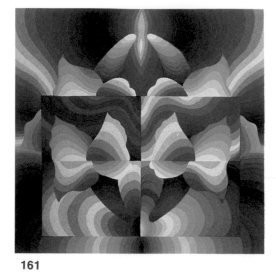

161

162

163

DESIGNS WITH UNRELATED HUES

We can systematically choose hues for a particular color scheme that exhibit certain relationships—either analogous or complementary hues, for instance. Three hues 120 degrees apart on the color circle are called *triads* and these are often combined in a color scheme. It is also possible that any number of hues can be chosen from the color circle at random to create an effective color scheme, provided that value and chroma are suitably manipulated.

Unusual color schemes can result from these unrelated hues, which are sometimes the product of an intuitive choice from among available colors. The dissimilarities of hues in varying degrees of hue contrast are thus emphasized.

Several unrelated hues of considerable chroma strength lead to multicolored effects (figs. 164–67). Unity can be achieved by using either warm or cool colors and by providing stronger hue contrast at the center of interest. Values can be manipulated by mixing the pigments, but if these are not mixed, the value of each color must be considered separately. The color scheme might also be expanded to include black and white.

Tinting all of its colors with a common hue also unifies a color scheme (figs. 168–70). This softens hue contrasts and establishes some analogy between dissimilar hues (see Part II, Hue Harmony). It is almost as if the colors are seen through a transparent colored filter, or under a colored light.

A Chinese character or components of the character are arranged on a dissected background in figures 164 through 167. Character shapes are sometimes dissected as well, creating more areas for color application.

The character strokes are joined as flat planes that do not overlap. Space in these designs is either occupied or unoccupied, and dissection introduces some ambiguity. The illusion of depth is not effected by the shapes, but more by the advance of warm colors and the recession of cool colors, particularly in figure 165, where yellow and pink become the center of interest, standing out from the cool colors that make up most of the design.

Figure 167 features a series of white diagonal lines that divide the design into numerous strips, separating all of the colors. The background is black. The overall design is muted compared to the vivacity of figure 164, the icy effect of figure 165, and the tranquility of figure 166.

The unrelated hues in figure 168 all have a greenish-brown tint, which creates a sense of warmth, though blue is present. The tint generally weakens the chroma of all the hues, keeping hue contrast to a minimum. The overall pattern has slightly overlapping shapes, which do not lend a great sense of depth to the design.

Figures 169 and 170 have a dominant orange-yellow tint, which unifies unrelated hues. The gradation of hue is used to soften the rotated, overlapping shapes. The effect of value gradations is even more significant than the effect of hue gradations, as the yellow-orange hue, lightest in value and strongest in chroma, makes distinct highlights.

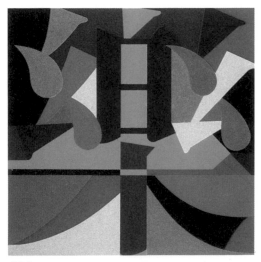

164

86

Designs with Unrelated Hues

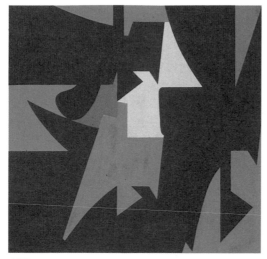

165

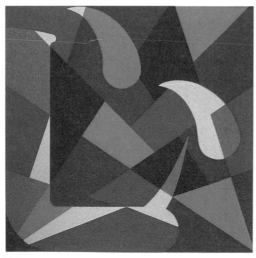

166

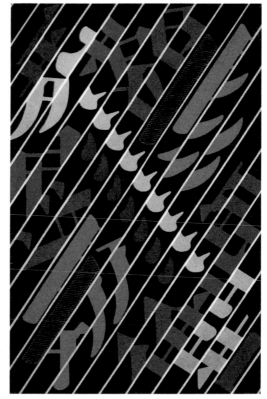

167

168

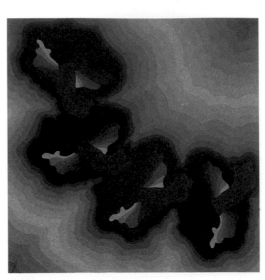

169

170

DEVELOPING A COLOR SCHEME

Innumerable options are available for developing a color scheme. A color circle is not limited to six basic hues, although color thinking is based on the simple six-hue device. Deviations from these basic hues can be regarded as hue adjustments, which moves a hue to one of its adjacent hues on the color circle. There are also value and chroma adjustments. The various adjustments offer thousands of colors that can be chosen and combined in a particular design.

A color scheme refers to the colors that are selected for a design; a group of colors that works well in one design may not be effective in another. This is because the positions of colors, the size of color areas, and the effects of simultaneous contrast must all be considered. Quick color sketches with a large assortment of felt-tip markers can be used to visualize these effects before a final decision is reached.

When developing a color scheme, we should begin by choosing a dominant hue and consider variations in value and chroma as well as additional hues. If a color scheme is restricted to only one hue, it is monochromatic, allowing value and chroma changes but no changes in hue. In most cases, a color scheme includes more than just one hue. The chosen hue can be accompanied by its adjacent hues to form a range of analogous colors. The wider the range, the more varied is the color sensation created by the design.

A dominant hue might be accompanied by a subordinate hue to provide necessary contrasts and occasional accents. The two hues may have a complementary or near-complementary relationship and can be extended to become split-complementaries. Hue adjustments sometimes obscure analogous or complementary relationships, which lead to a color scheme of unrelated hues.

When the hues have been determined, value and chroma adjustments and variations should be considered. We might, alternatively, decide whether the composition will be of high key, intermediate key, low key, uniform value, maximum chroma, or minimum chroma, before choosing the hues for the color scheme.

A Color Scheme with Analogous Hues

A Color Scheme with Complementary Hues

Analogous hues generally express a soft harmony, stressing similarities rather than differences between the hues. Hue contrast still exists, however, when the beginning and end hues in a range of analogous hues are compared.

Hue contrast is evident in figure 171 —purple-red is next to purple-blue and other blues. The use of both warm and cool colors enhances the effect of the contrast between hues. Hue contrast is also present to a lesser extent in figures 173, 175, and 177. It is least apparent in figure 174, which exudes a sense of warmth; contrast exists only in the values of hues.

A neutral gray is part of the color scheme in figures 172 and 176. Simultaneous contrast alters the way gray is perceived, which makes the color scheme appear more varied; complementary contrast is faintly expressed, with gray acting as the complementary hue.

Figures 178 through 181 have color schemes with split-complementary hues. Figure 182 has intermixed complementary hues, and figures 188 through 190 feature complementary hues with value adjustments.

None of the designs here exhibits very strong hue contrast. Strong value contrast is apparent in figures 178 and 181; scintillation occurs in the lightened blue adjacent to the darkened orange shapes. In figures 179, 180, and 182, most of the hues are of weaker chroma strength, which reduces the harshness of complementary contrast.

Examples of Color Schemes

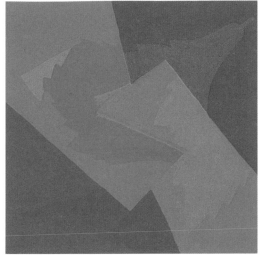

171

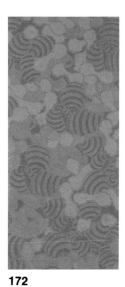

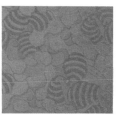

172

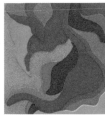

173

174

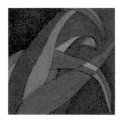

175

176

177

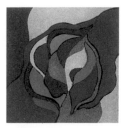

178

 179

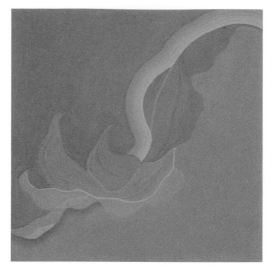

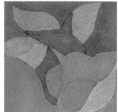

180

181

182

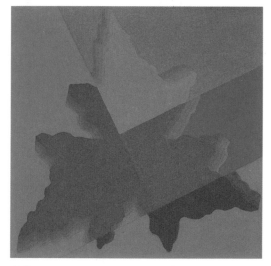

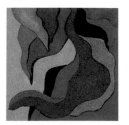

184

185

186

187

183

A Color Scheme with Unrelated Hues

The Control of Value and Chroma in a Color Scheme

Deviations from analogous or complementary relationships establish color schemes of unrelated hues (these can include triads or near-triads).

A color scheme of unrelated hues is multicolored if most of the hues have strong chroma (see figs. 164–66). Figures 183 through 187 feature subdued colors with considerable variations in value.

It may not be easy to identify a color scheme of unrelated colors. For instance, figure 183 resembles a color scheme with analogous hues; figure 184 could be mistaken for a color scheme of split-complementary hues. This does not really matter. Most important is that we arrive at an effective and interesting color scheme.

After hue adjustments are made to a color scheme, the value and chroma of colors are manipulated. A hue is either heightened or lowered in value, strengthened or weakened in chroma. The value and chroma of a hue are related, so a change in one can easily affect the other. Values might be closely related to enhance chroma contrast. It is also possible to weaken chroma without changing the values of hues if these are mixed with grays of the same value.

Figure 188 is in the high key. Orange here is of strong chroma, appearing slightly darker than the light blues, which create luminous shadows around the shapes. Figure 190 is also in the high key; all colors here are within one value step, with yellow in full radiance among the blue and orange hues of much weaker chroma.

Figure 189 is in the intermediate key. Purple is heightened in value, but its chroma is intense enough so that it contrasts with the yellow-green hue. Purple and yellow-green are mixed, resulting in a slight lowering of value to provide subtle value and chroma contrasts.

Figures 191 and 194 are in the low key. Figure 191, especially, has uniform value throughout the design, with dark orange shapes emerging from the blue ground and other adjacent dark hues. Figures 192 and 193 are also in the low key, but slightly lighter values are used as accents.

These illustrations are not restricted to particular hue relationships. Figures 188 through 191 feature complementary hues; the rest feature unrelated hues. We should refer to the illustrations presented earlier in this section to see the effects of changes in value and chroma. For instance, figures 176, 177, 179, and 183 all contain significant adjustments in value.

It is useful to experiment with a wide variety of color schemes for a single composition. Figure 195 explores thirty-six variations, yet the composition remains almost unchanged.

The range includes monochromes, analogous hues, complementary hues, unrelated hues, and colors of closely related values. These five different approaches can be seen as the basic directions we might head in our search for an effective color scheme.

More Examples of Color Schemes

188

189

190

191

192

193

194

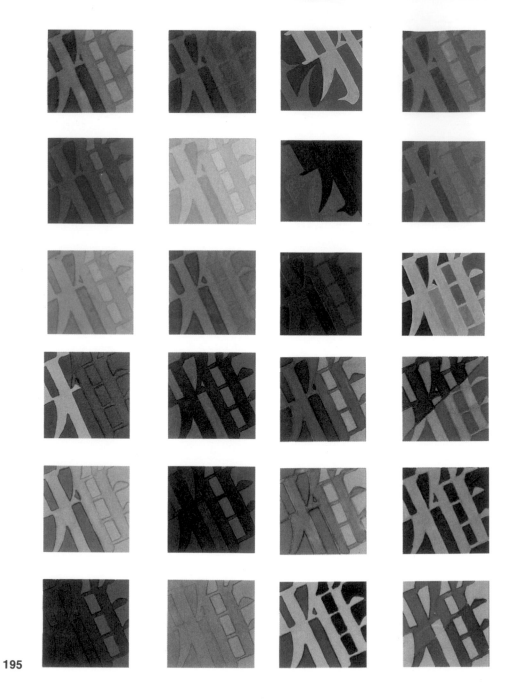

 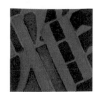

 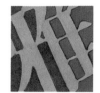

 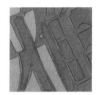

 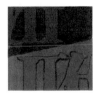

INDEX